Saving Graces

Saving Graces

Images of Women in European Cemeteries

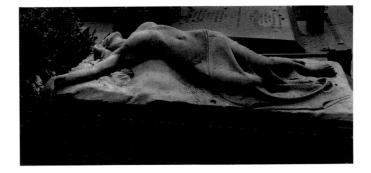

DAVID ROBINSON

FOREWORD BY JOYCE CAROL OATES

W.W. NORTON & COMPANY

NEW YORK · LONDON

Photographs and text © 1995 by David Robinson
Foreword © 1995 by Joyce Carol Oates

Printed in Singapore

Reissued as a Norton paperback 1999

The text of this book is composed in Weiss
with the display set in Weiss
Maunufacturing by CS Graphics PTE Ltd.
Book design by Debra Morton Hoyt

Library of Congress Cataloging-in-Publication Data
Robinson, David.
 Saving Graces/David Robinson.—1st ed.
 p. cm.
 1. Sepulchral monuments—Europe. 2. Sculpture, Modern—
 19th century—Europe. 3. Women in art. 4. Symbolism in art—Europe.
 I. Title.
 NB1859.R63 1995
 730'.94'09034—dc20
 95-4069

Title page photograph: *Monumentale.* Milan, Italy
Photograph on page 6: *Père Lachaise.* Paris, France

ISBN 0-393-03794-0
ISBN 0-393-31333-6 (pbk.)

W.W. Norton & Company, Inc., 500 Fifth Avenue, New York, N.Y. 10110
W.W. Norton & Company, Ltd., 10 Coptic Street, London WC1A 1PU

1 2 3 4 5 6 7 8 9 0

To Carol and to Alexandra

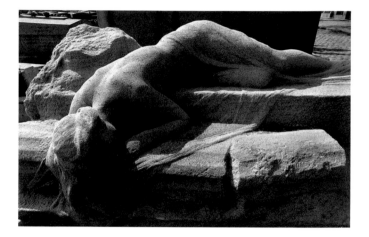

ACKNOWLEDGMENTS

Like all creative endeavors, this series of photographs and the resulting book would not have been possible without the support and encouragement of several friends. My wife, Carol, has been an enthusiastic and stimulating partner throughout. I can also always count on both Carol and my daughter, Alex, for a combination of sound counsel and good cheer. Martine Renaudeau d'Arc gave Carol and me shelter, guidance, and friendship during our two years in Paris while I was photographing European cemeteries. I also want to thank Dale Parker of Advanced Photographics and Kathy Rose for their production and lab work, Berenice Hoffman for her cogent editorial and publishing advice, and Greg Palmer for including photographs from *Saving Graces* in his excellent PBS series, *Death, the Trip of a Lifetime*. I am grateful to La Maison Française at New York University, the Boston Public Library, and the Boston Museum of Fine Arts for the shows and lectures related to this material which they sponsored. The many people who have collected these photographs have helped keep me going and are much appreciated. I also want to thank my editor, Jim Mairs, whom I met through a generous introduction from Rosamond Purcell, for his support and advice, and Joyce Carol Oates for her kind words and insightful comments.

FOREWORD

There is the photography of life—of the living, breathing, split-second moment; and there is the photography of stillness—of the arrested, meditative image. The work of photographers as diverse as Henri Cartier-Bresson and Weegee takes as its upremeditated subject the quicksilver instant when an image is almost literally snatched out of the torrential flow of time: the photographer is a hunter, a stalker, a transcendent species of predator, reacting to instinct, genius in motion. By contrast, the work of photographers as diverse as E. J. Bellocq, Eugène Atget, Edward Weston, and Diane Arbus takes as its subject the calculated, deliberated image: the photographer is supremely in control, the camera is not in motion, accidental illumination is not the goal. Such photographs are more likely to be compositions; portraits of a kind, whether of living people, or "still lives," or, as in the case of these haunting "graces" of David Robinson, existing works of art. The thematic and emotional significance of the portfolio *Saving Graces* is a richly accumulative one: as individual compositions, these studies of nineteenth-century European cemetery statuary are striking and provocative, but only as a sequence, as a narrative of a kind, do they yield their most powerful symbolic meanings.

Most cemetery sculpture, whether of grieving female figures, Jesus Christ in His various incarnations, angels and cherubs, heraldic crosses, obelisks, icons, urns, is a testament to mankind's obsession with mortality. These lovely "saving graces" which Robinson's contemplative eye has isolated for us constitute an especially poignant revelation of such fantasies: the sculptures depicted are, as the photographer has

noted, not standardized figures but ones representative of serious artistic expression. In these pages we see with contemporary eyes the love objects of the previous century; icons of a church in which we no longer believe. Such compelling images of idealized, etherealized, and in some cases eroticized embodiments of ritual mourning.

The distinguished American photographer David Robinson's account of his discovery of these "graces" in European cemeteries reads like a mystery in which the photographer, led by his camera, is a kind of detective. Who are these beautiful women?—whom are they mourning?—what is their symbolic significance? Classically austere and occasionally featureless, at one extreme; at the other, romantically voluptuous, barely clothed, in some cases starkly nude; lying, like the lovely figure gracing the cover of this book, in a pose of swooned, vulnerable abandon, as if grief were a form of erotic surrender. What the figures have in common, of course, is that they are female, and that they belong to another era, indeed an entirely *other* dimension of mythologized experience.

Though these sculptures belong to the nineteenth century, and the graves they adorn are, for the most part, those of European bourgeois men, we see no nineteenth-century Europeans depicted here. There are no grieving widows of any recognizable type, no middle-aged or older women; no mothers, or children. There are no hefty, or emaciated, or plain-faced, let alone unattractive mourners. No sons, brothers, fathers, male relatives—no masculine figures at all. (The masculine, or androgynous, stone figures of representative Christian cemeteries are of course angels, who do not collapse in unseeming "womanly" grief. Their allegiance is to Heaven, where grief is irrelevant.) In these mute rituals the deceased are mourned as the gods, demigods, and beautiful youths (like Narcissus) were mourned in antiquity, by Muses, nymphs, naiads, dryads. (Ovid's great work *The Metamorphoses* is the very poem of such female mourning, though "Sisters of the sacred well"—the Muses of Mt. Helicon—are evoked in John Milton's elegy. *Lycidas*, a presumably Christian poem imagined as a pagan ecologue.) Women presumably died in as great numbers as men, mothers, wives, daughters, yet the "saving graces" rarely mourned them; and when so publicly mourned, it would hardly have been in the eroticized images

of comely young men.

Saving Graces is an assemblage of strikingly beautiful photographs that tells us much, and hints at far more, of our collective desire that death be not mere deadness—biological decay, cellular decomposition, the extinction of the "unique" human personality—but Death: mysterious, ethereal, mourned and therefore celebrated by the most attractive among us. Contemplating these images, we realize how human anxiety, human vanity, human terror of the unknown, whether male or female, may well be the unacknowledged origin of our greatest artworks.

— JOYCE CAROL OATES

Père Lachaise. Paris, France

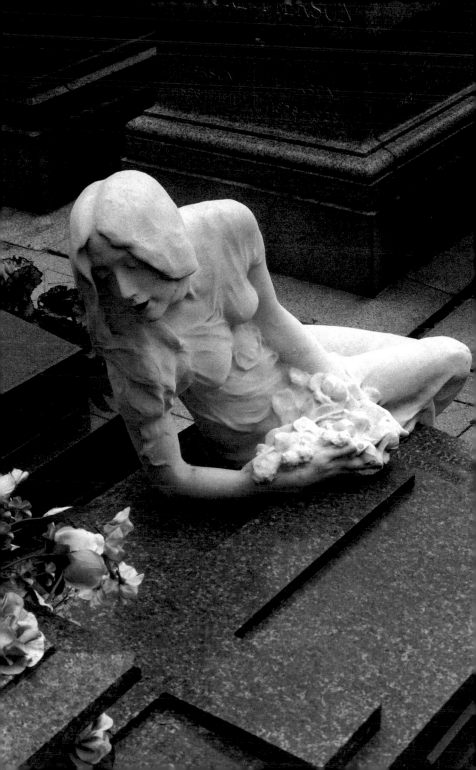

Budapest, Hungary.

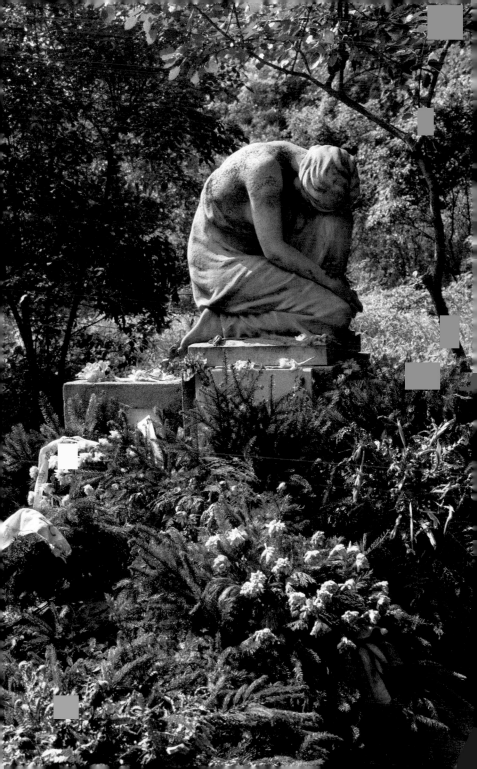

Père Lachaise. Paris, France

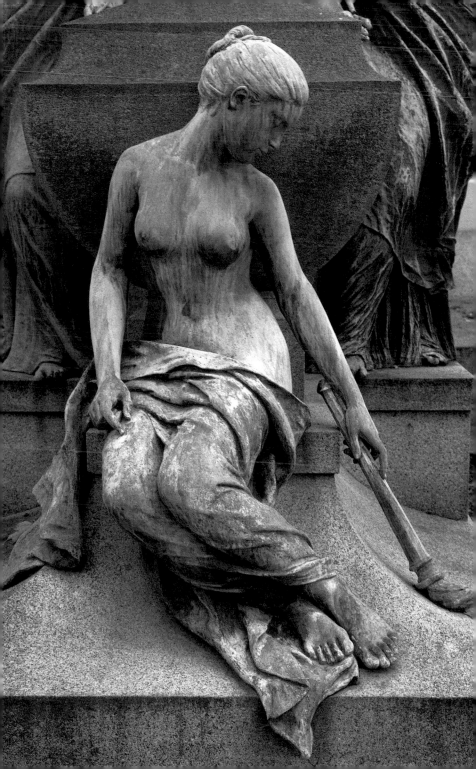

Staglieno. Genoa, Italy

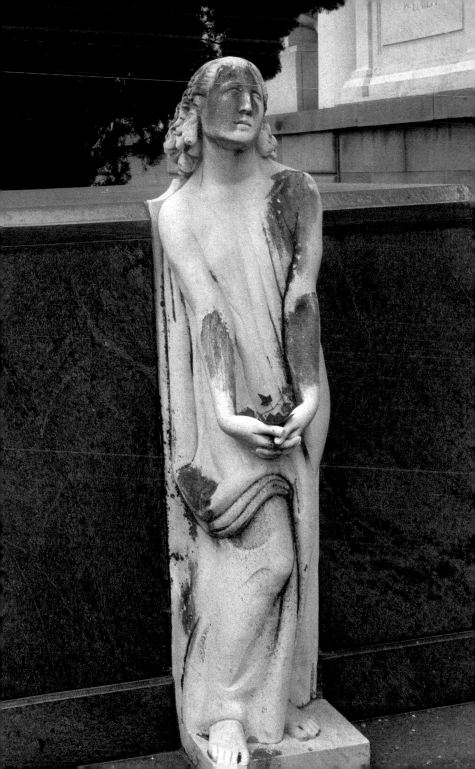

Père Lachaise. Paris, France

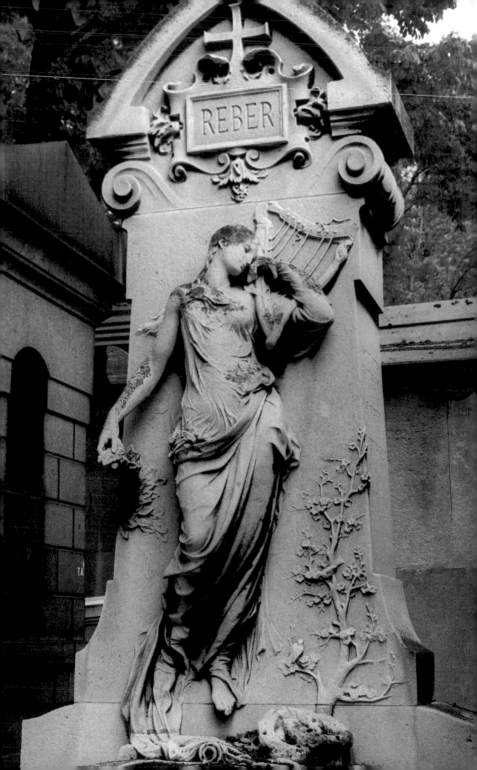

REBER

Kensal Green. London, England

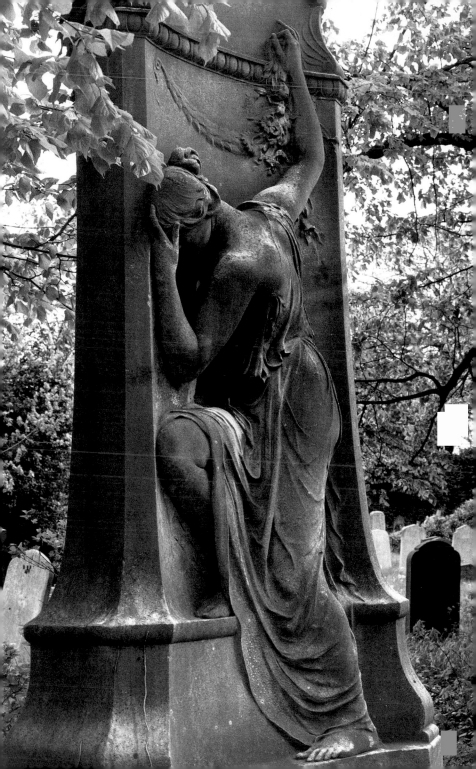

Monumentale. Milan, Italy

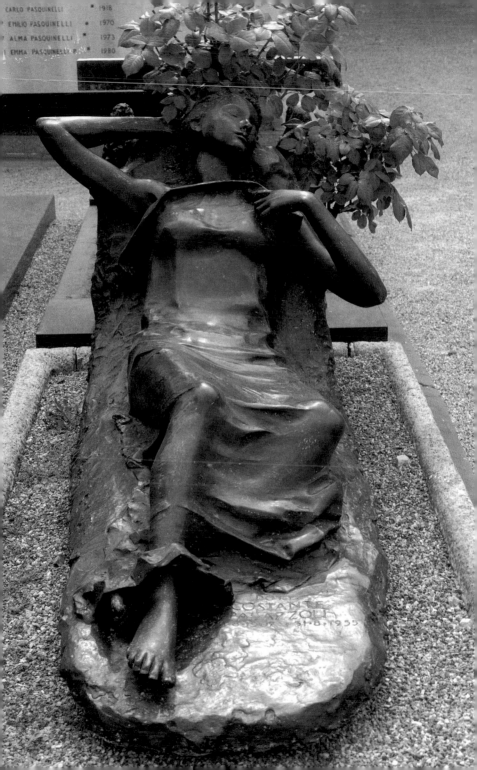

Père Lachaise. Paris, France

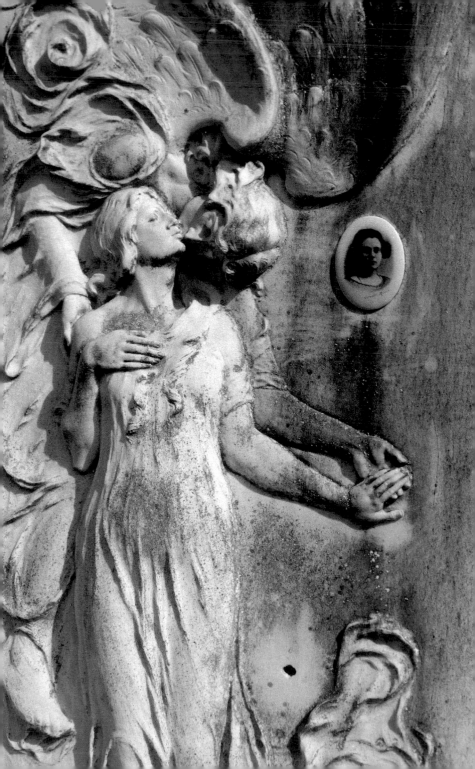

Montmartre. Paris, France

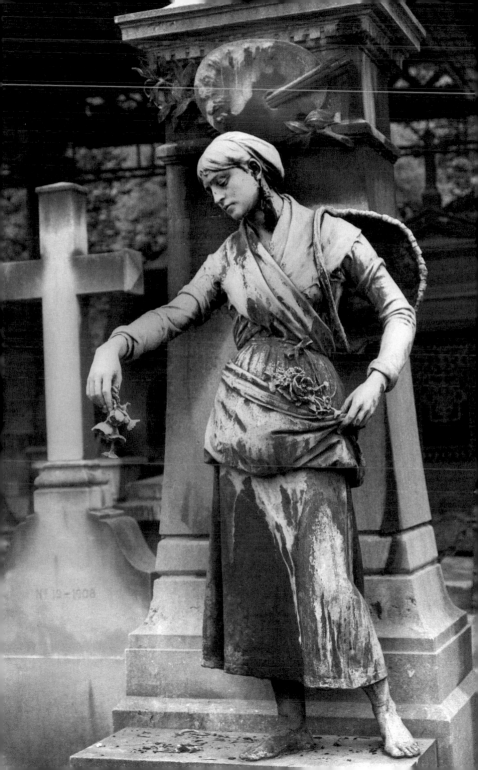

Passy. Paris, France

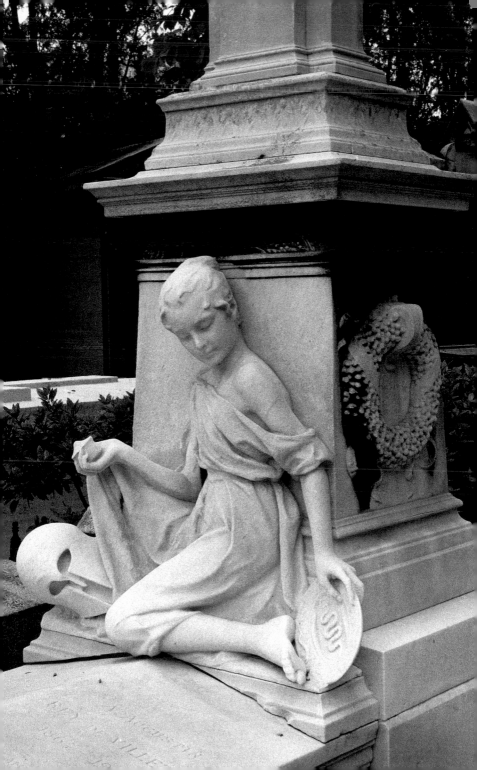

Montmartre. Paris, France

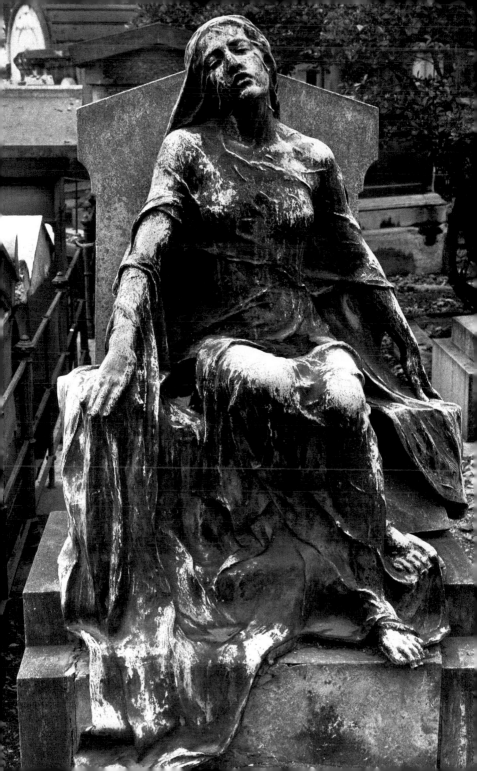

Père Lachaise. Paris, France

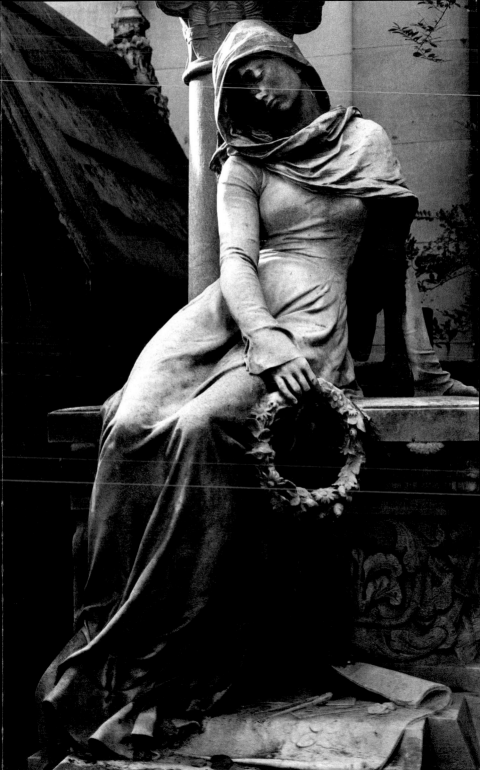

Père Lachaise. Paris, France

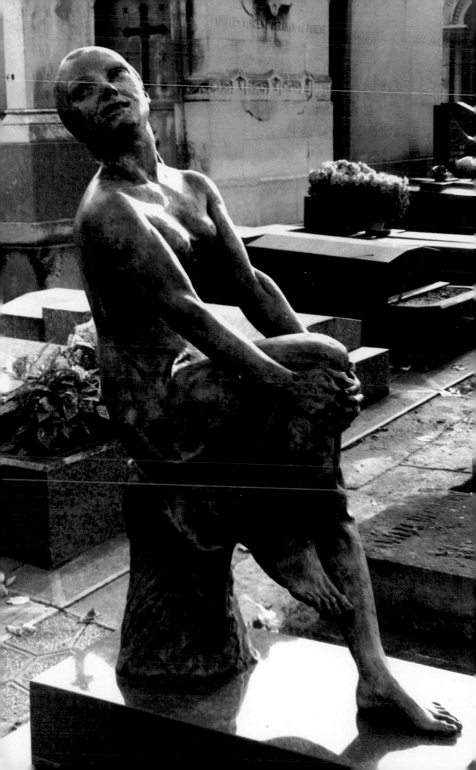

Monumentale. Milan, Italy

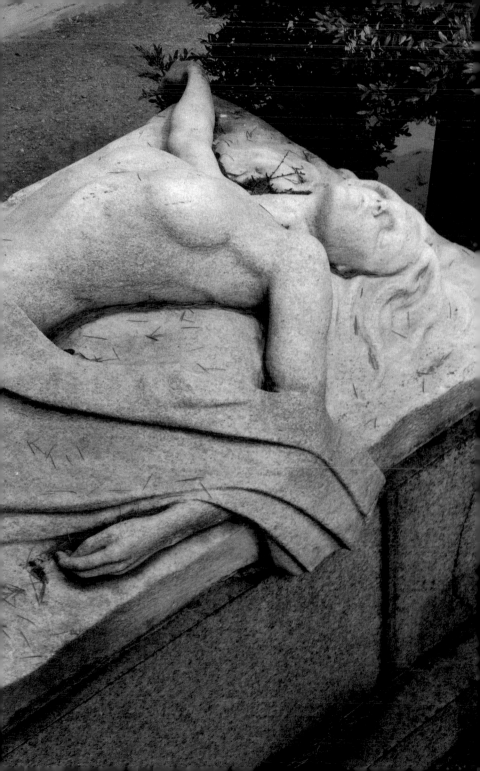

Père Lachaise. Paris, France

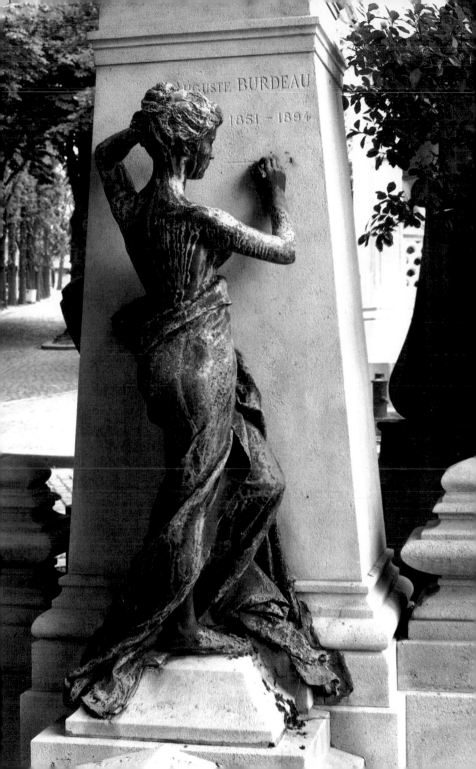

Auguste BURDEAU
1851 – 1894

Montmartre. Paris, France

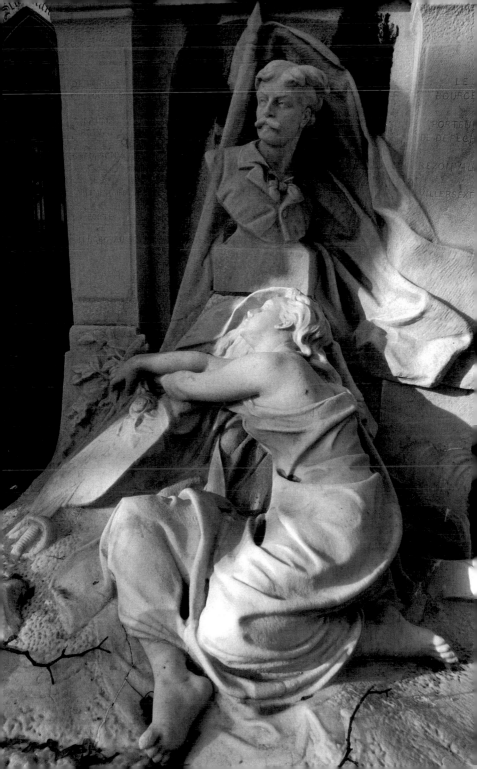

Père Lachaise. Paris, France

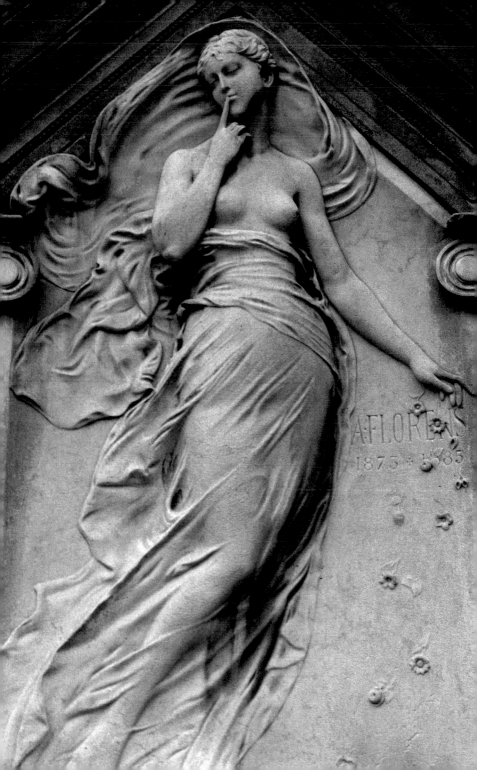

Staglieno. Genoa, Italy

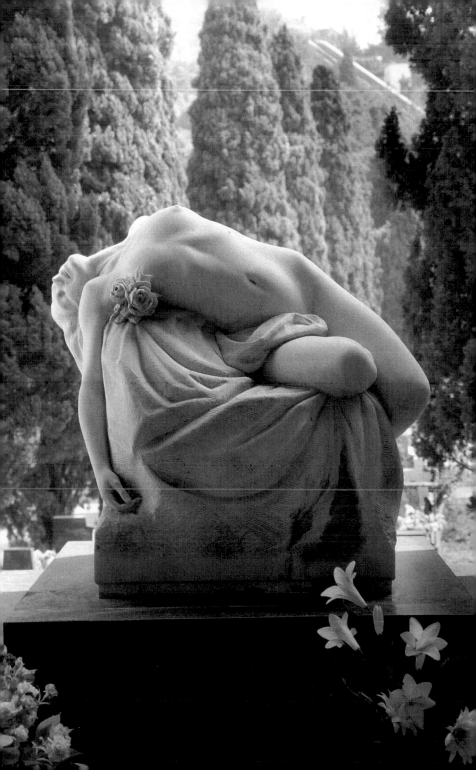

Montparnasse. Paris, France

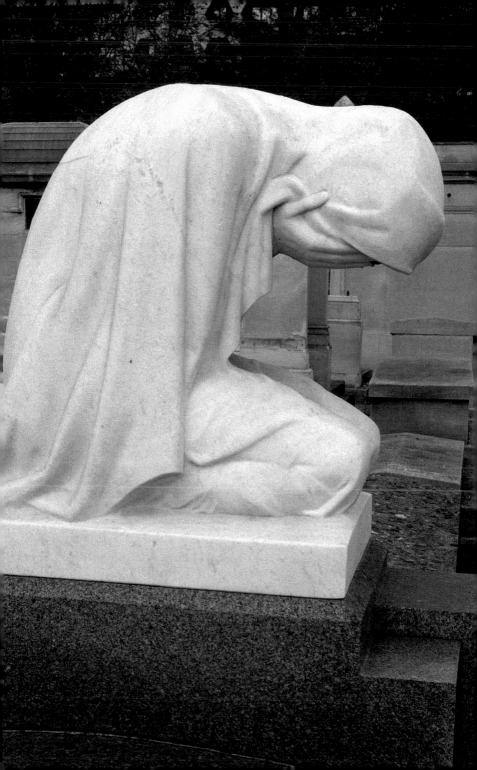

Père Lachaise. Paris, France

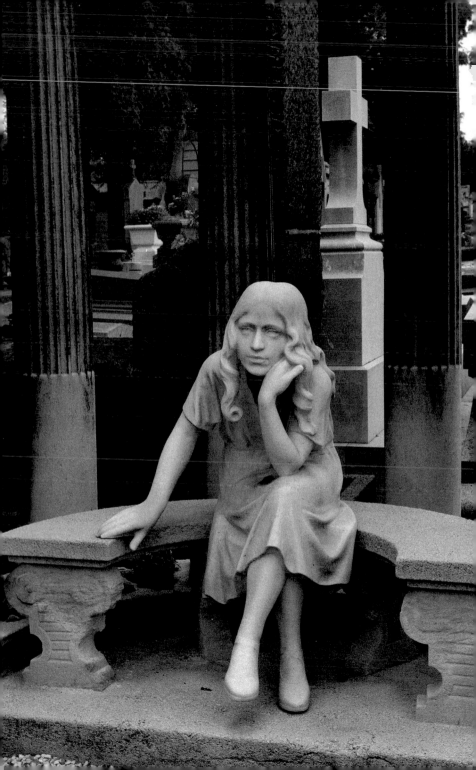

Montmartre. Paris, France

SERGENT AV 26ᵉ REGᵗ D'INFᵗ
MORT ET INHVME
AV CHAMP D'HONNEVR
LE 9 MAI 1915
A L'AGE DE 30 ANS

Père Lachaise. Paris, France

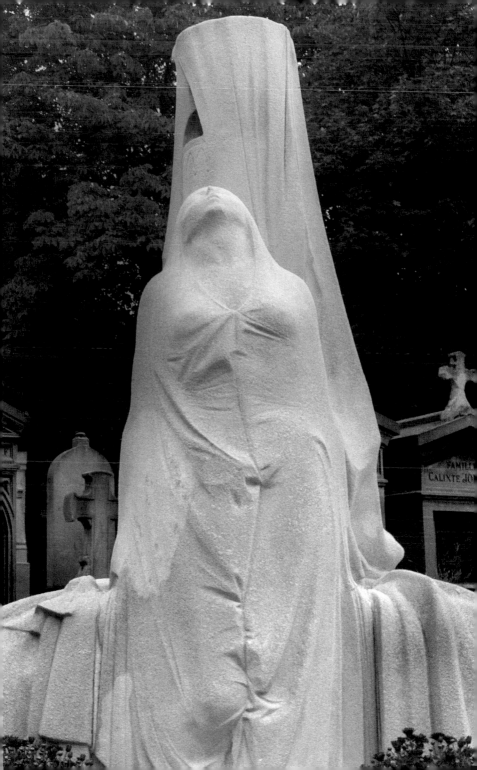

Montmartre. Paris, France

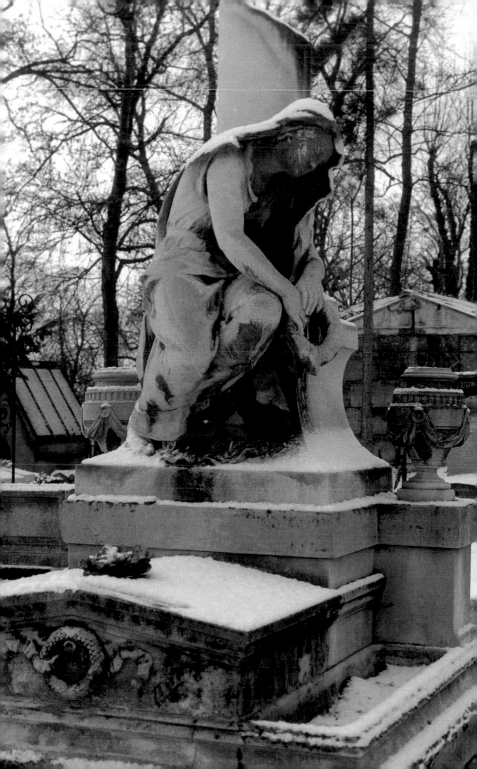

Père Lachaise. Paris, France

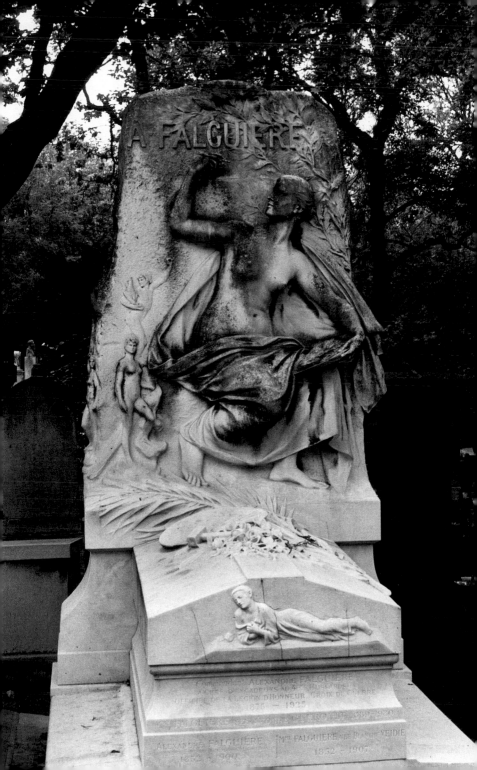

Passy. Paris, France

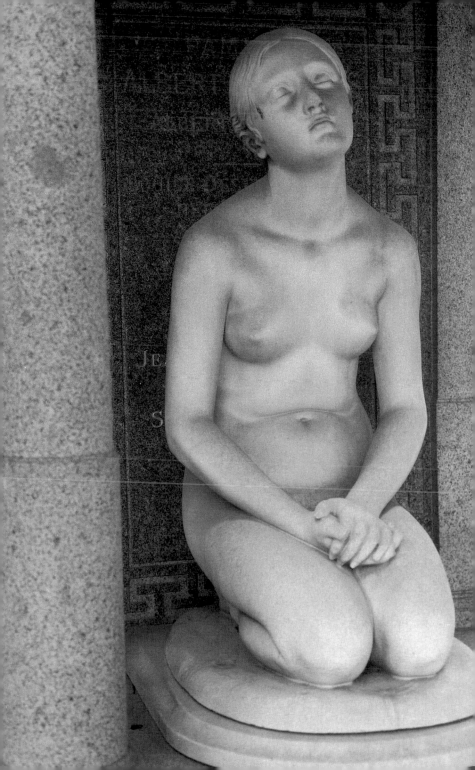

Monumentale. Milan, Italy

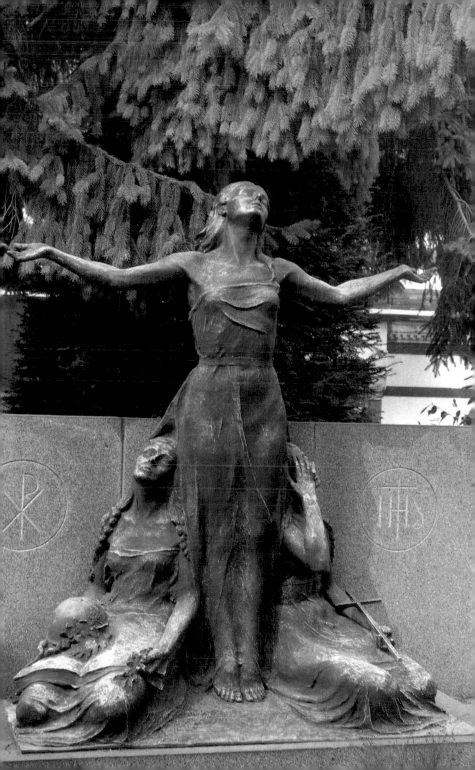

Monumentale. Milan, Italy

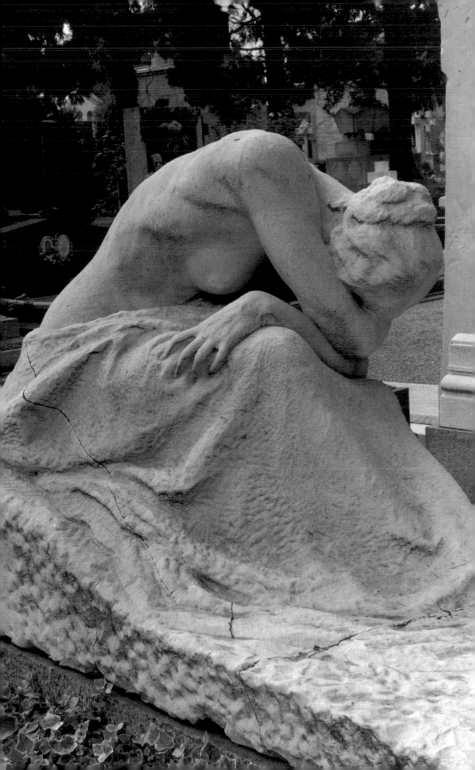

Highgate. London, England

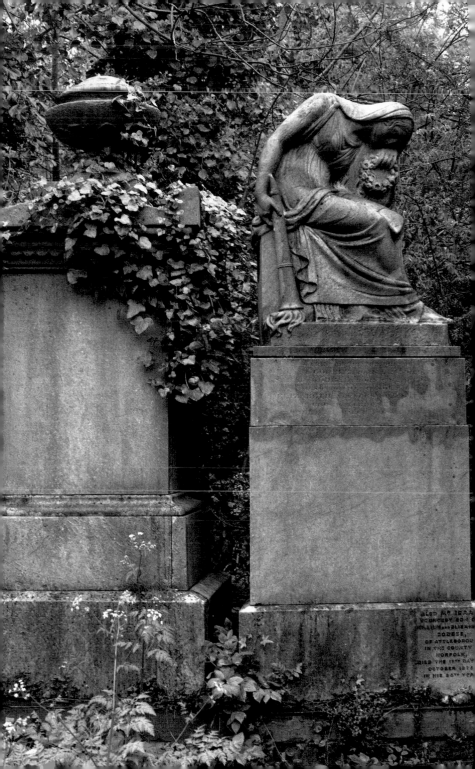

Staglieno. Genoa, Italy

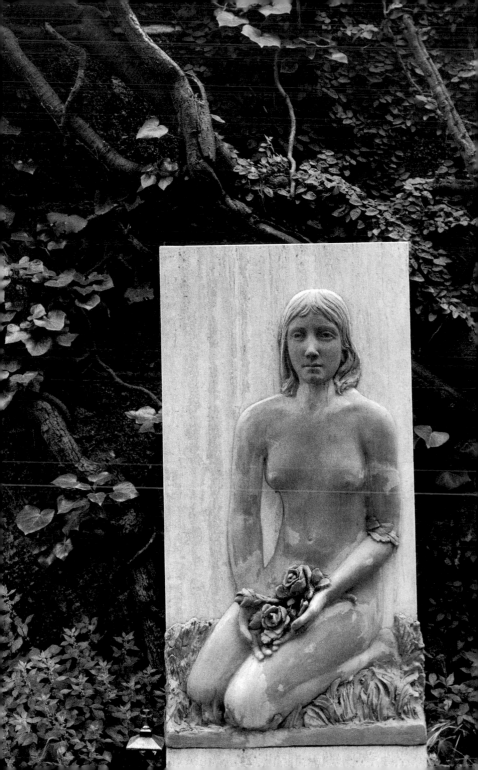

Ober St. Veit. Vienna, Austria

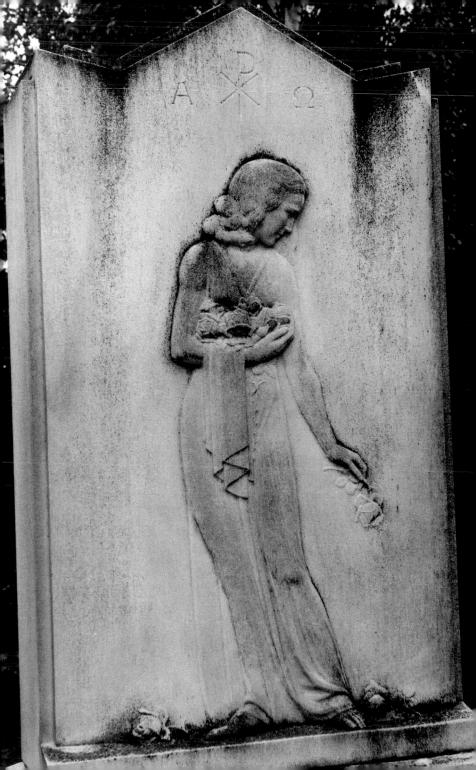

Père Lachaise. Paris, France

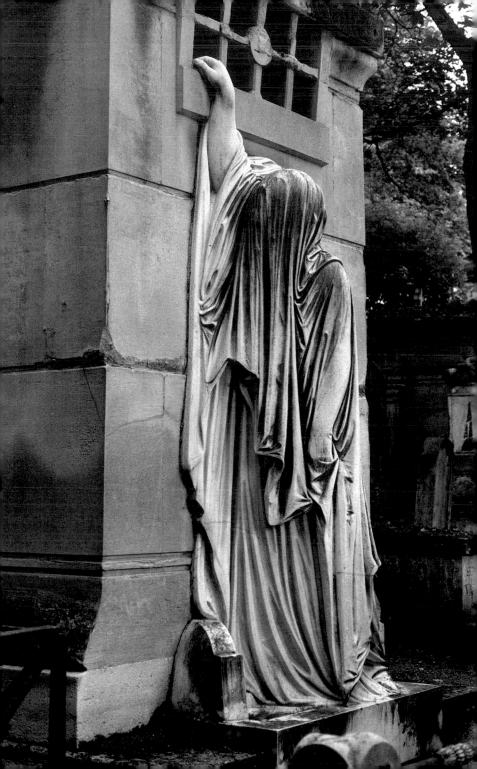

Père Lachaise. Paris, France

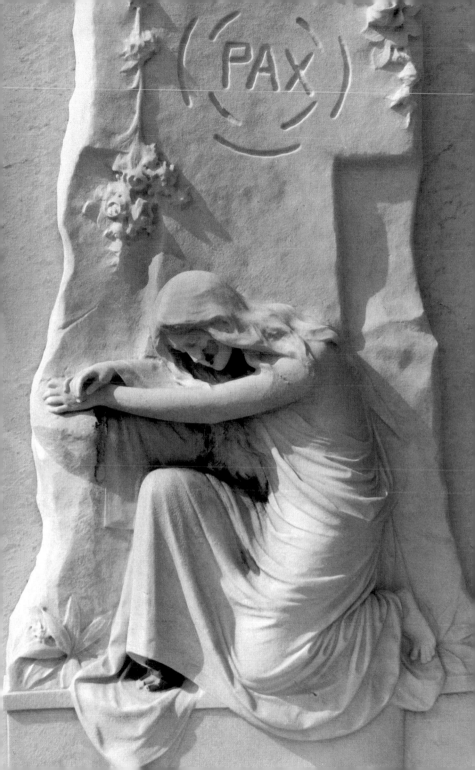

Monumentale. Milan, Italy

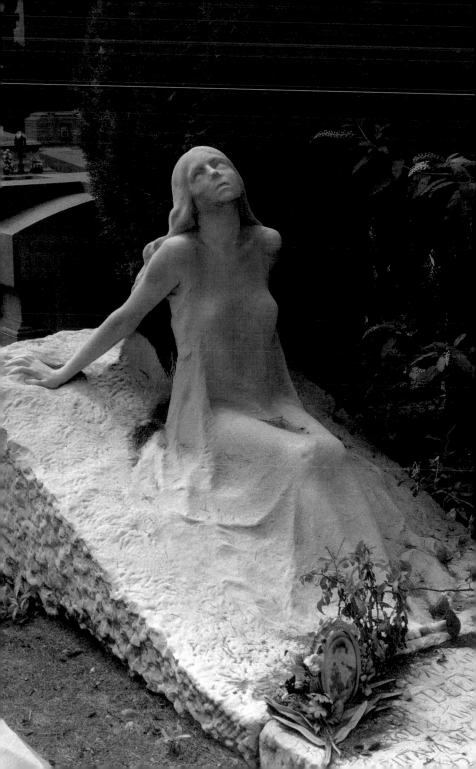

Monumentale. Milan, Italy

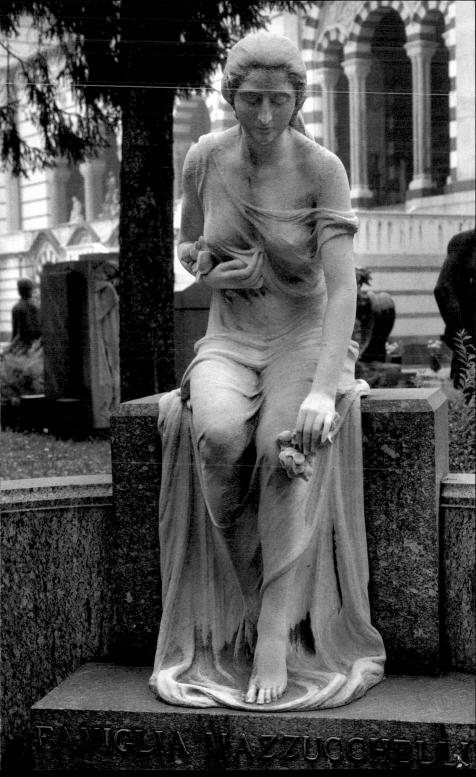

FAMIGLIA MAZZUCCHELLI

Père Lachaise. Paris, France

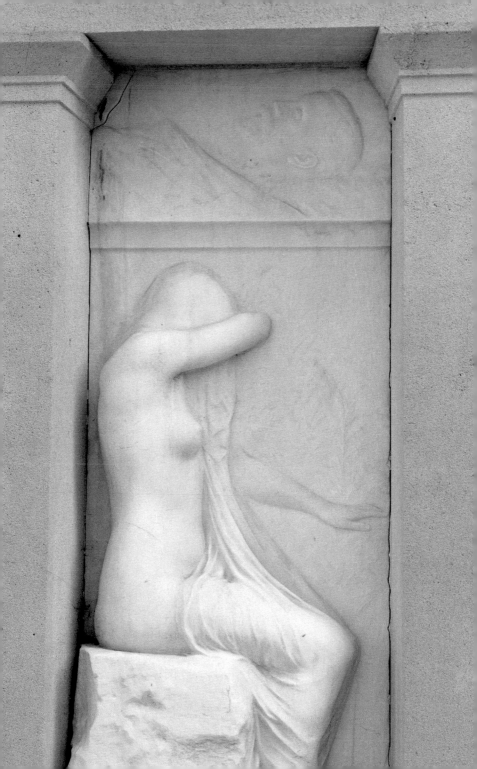

Monumentale. Milan, Italy

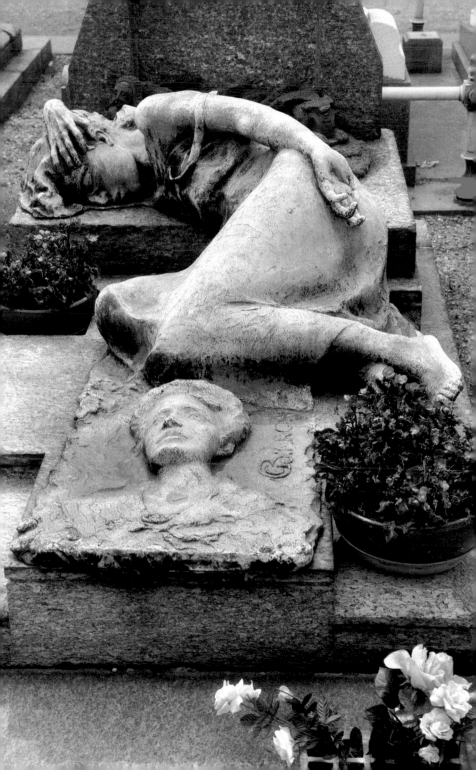

Montmartre. Paris, France

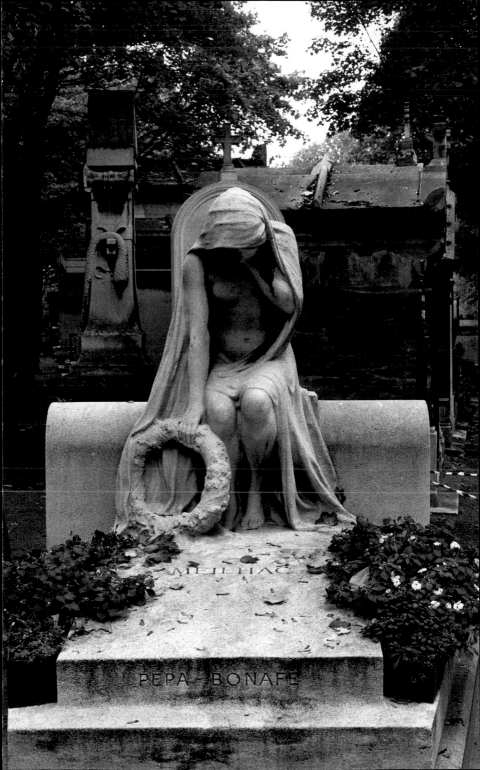

Versailles, France.

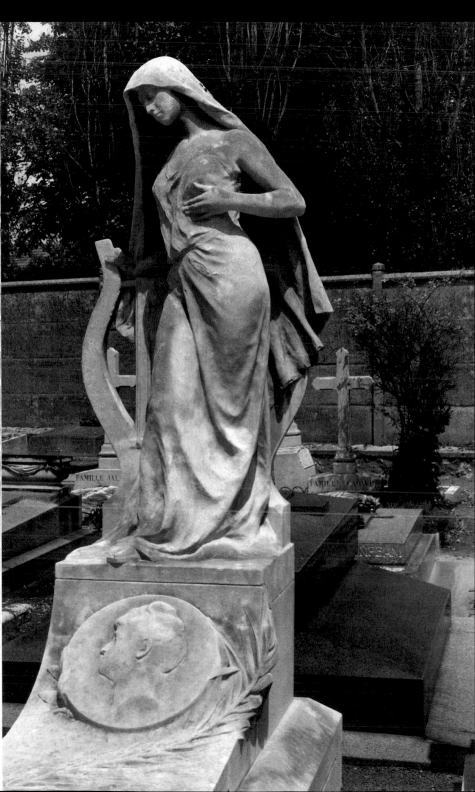

Monumentale. Milan, Italy

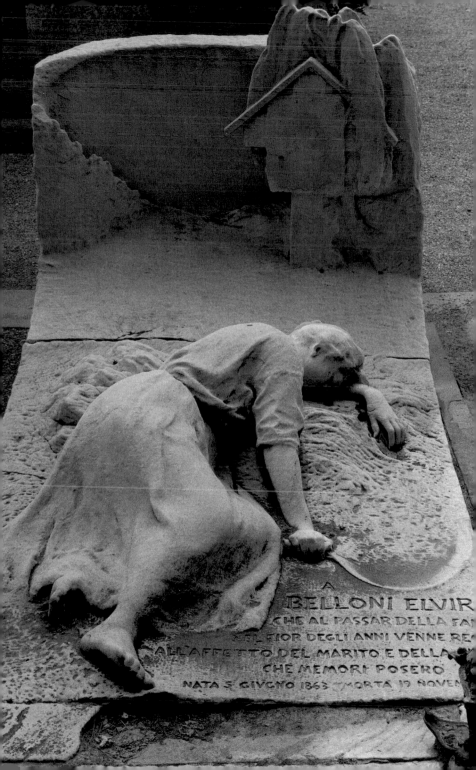

Père Lachaise. Paris, France

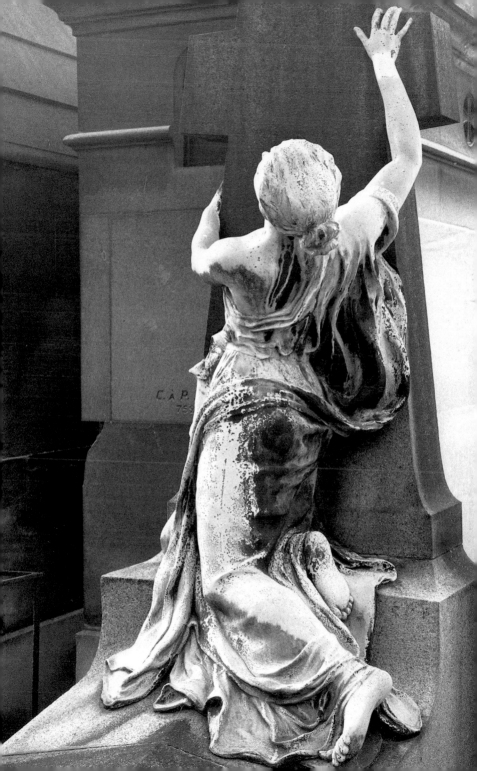

Père Lachaise. Paris, France

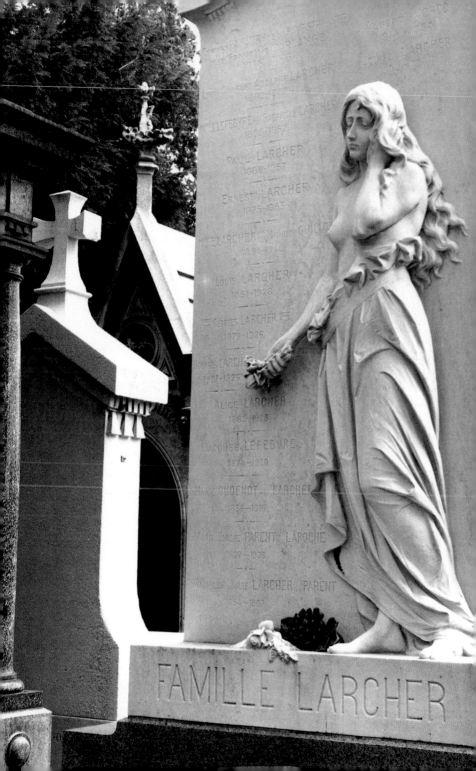

Monumentale. Milan, Italy

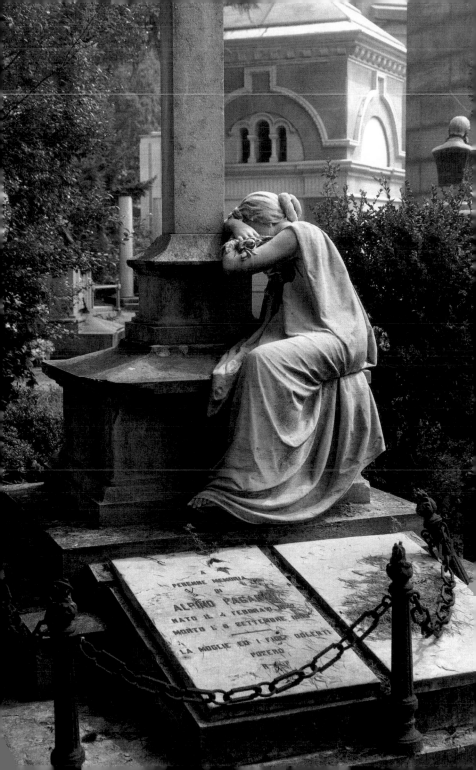

Monumentale. Milan, Italy

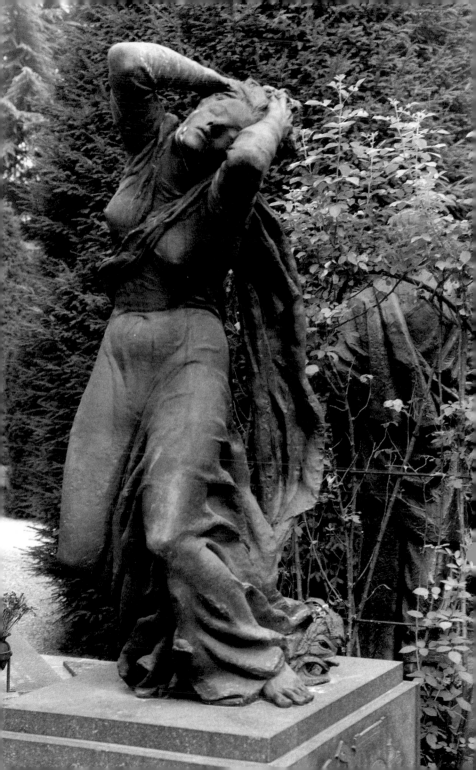

Passy. Paris, France

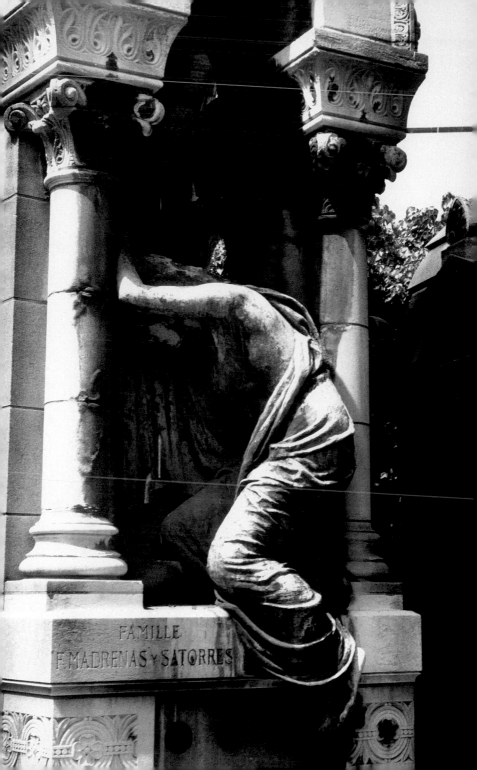

FAMILLE
F. MADRENAS Y SATORRES

Monumentale. Milan, Italy

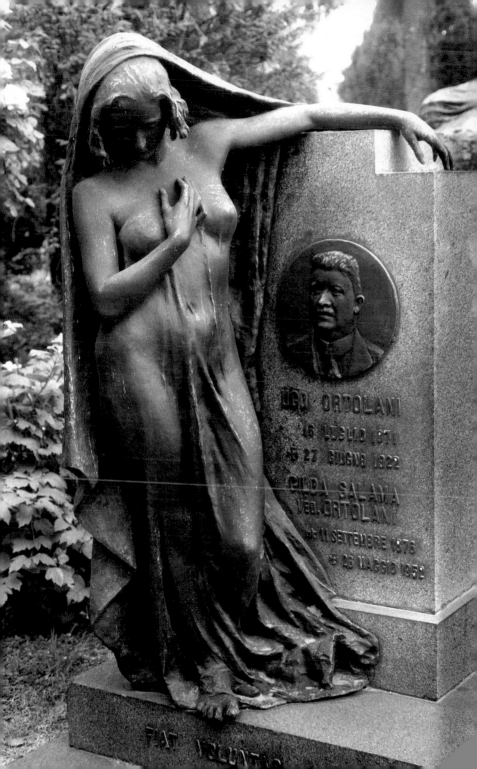

UGO ORTOLANI
16 LUGLIO 1871
✝ 27 GIUGNO 1922

GILDA SALAMA
Ved. ORTOLANI
✝ 11 SETTEMBRE 1875
✝ 26 MAGGIO 1952

FIAT VOLUNTAS

Père Lachaise. Paris, France

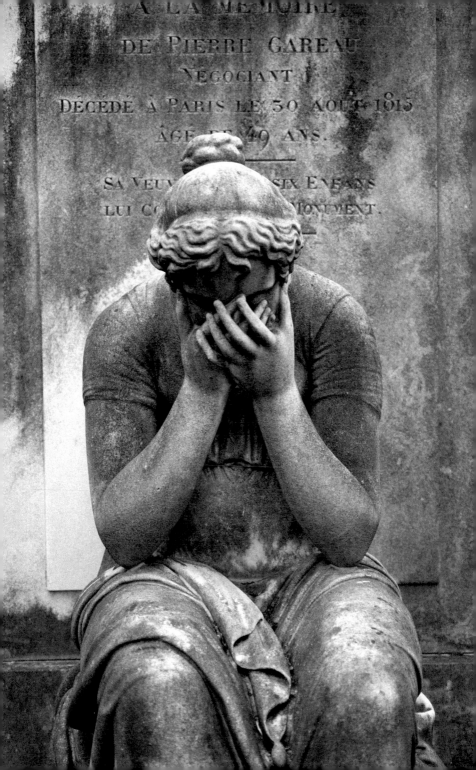

Père Lachaise. Paris, France

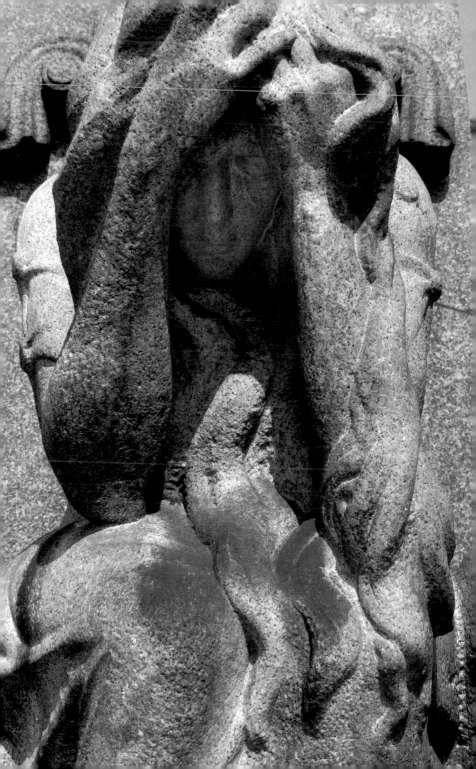

Père Lachaise. Paris, France

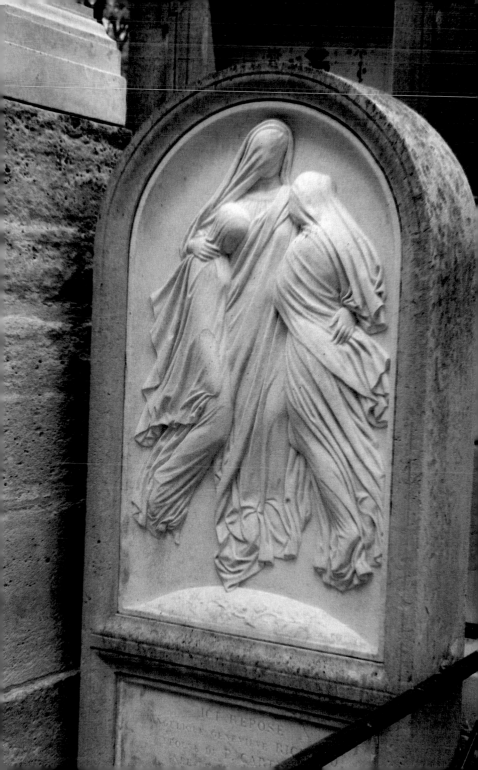

ICI REPOSE
ANGÉLIQUE GENEVIÈVE RIC
ÉPOUSE DE P. CART

Monumentale. Milan, Italy

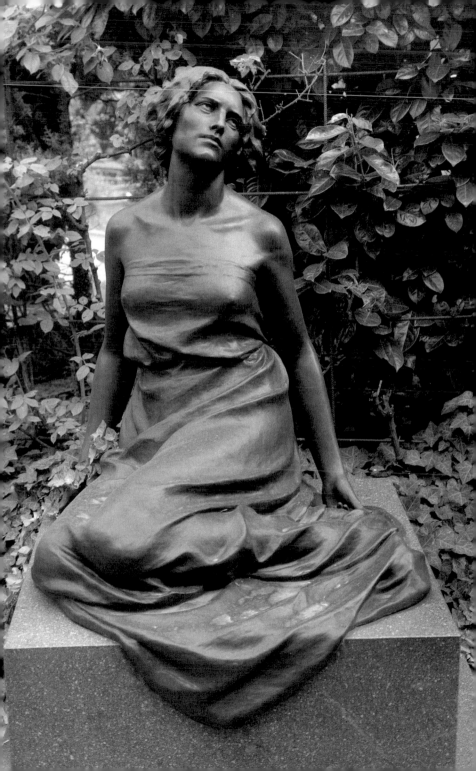

Monumentale. Milan, Italy

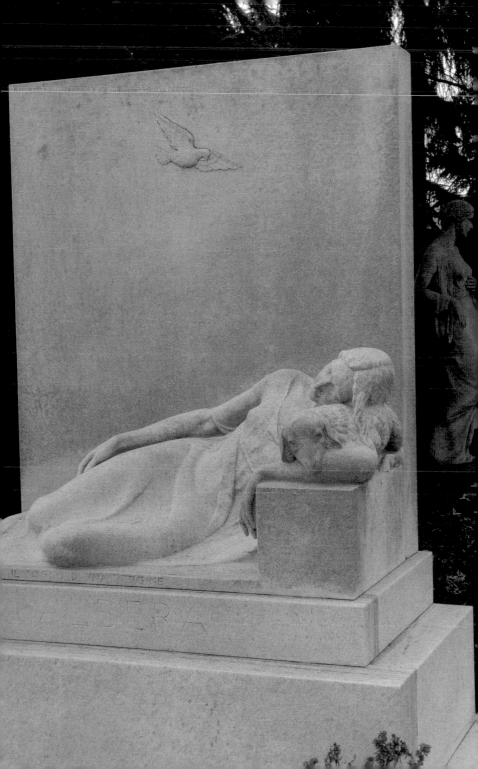

Monumentale. Milan, Italy

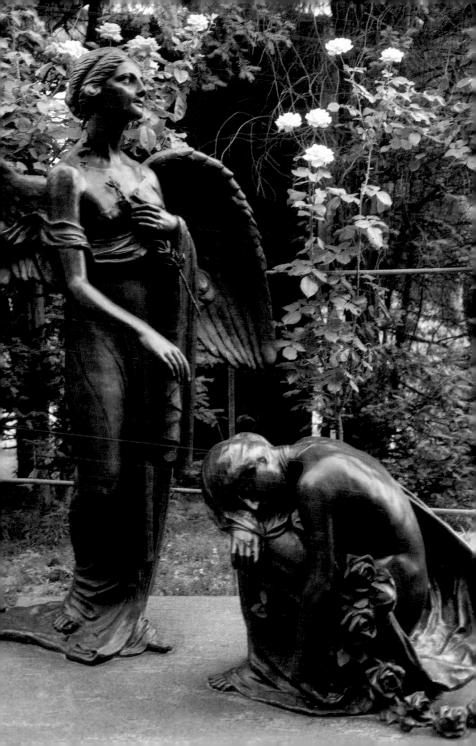

Père Lachaise. Paris, France

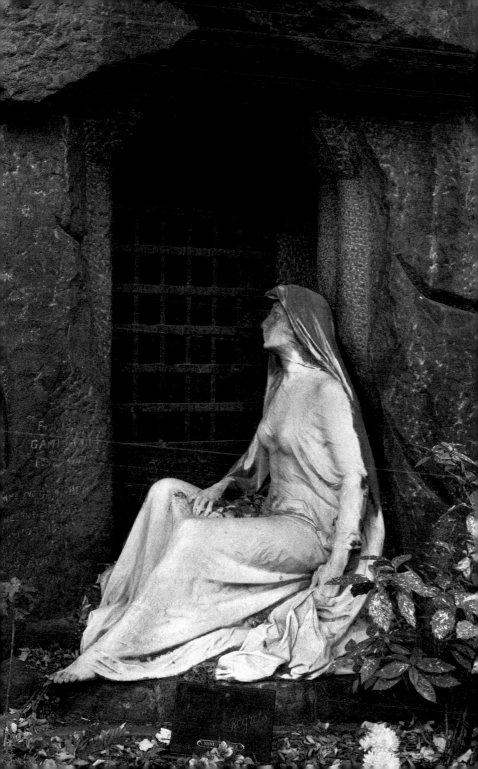

A F T E R W O R D

When I was photographing in Père Lachaise and other
European cemeteries, I soon became aware of women all
around me. We are familiar with the image of widows dressed in black
bending over to tend family graves, and indeed, European women are
dutiful visitors to their cemeteries, where in a mixture of devotion and
socializing they clean the gravestones, water the flowers, pay their
respects to the deceased, feed the cats, and pause to talk with their
neighbors.

But these were not the women who attracted my attention.
Instead, I found myself transfixed by gorgeous young women who were
not dressed in black. In fact, many were hardly dressed at all, and
although exquisitely beautiful, they were visibly distraught. Père
Lachaise was full of them. They were very lifelike, and I could easily
convince myself they were real. While the older women were tending
the graves, the younger ones—those marble beauties—were adorning
them.

It was clear from the beginning that this was a particular catego-
ry of women who had a special role to play in mourning the dead.
After some time, I began calling them the "Saving Graces" because of
their beauty and their beneficence.

The sculptors had spared no effort in giving these statues the full
range of emotions surrounding death, and they brought great skill to
their task. Like rose petals scattered on grey pavement, the Saving

Graces give the cities of the dead an aspect of life.

Who were these women, and what where they doing in the cemeteries? What exactly was their role? My curiousity piqued, I started photographing them systematically. And the more I looked, the more of them I found—not only in Père Lachaise but in the other Parisian cemeteries as well.[1] As I traveled, I discovered similar statues of weeping women in Christian cemeteries throughout Europe. It was evident that this was not an isolated local custom but a fairly common form of dealing with the emotions of grieving. However, the exact role of the Savings Graces continued to puzzle me.

The first question I had to address was whether the Saving Graces were in any way portraits of the deceased. Could it be possible that these were all similarly young, beautiful women who died premature deaths, the result of some sort of targeted plague? The answer had to be negative; no beloved wife or daughter would be portrayed naked on her tomb. Clearly, the women adorning family graves were not in any way meant to be portraits of specific individuals. These were idealized and symbolic figures.

In order to understand their specific role, I began to look at representations of men in the cemeteries as well, to discern what differences there were between the images of men and those of women. I could find no mourning men, nor men depicted in paroxysms of grief, or even kneeling.[2] Men are not the bearers of sorrow; that role is clearly left to the women. As Greg Palmer noted in his PBS television series, *Death, the Trip of a Lifetime*, in many cultures women are "the designated grievers."

The men portrayed in the cemeteries are figures of substance— real men, and clearly intended to be portraits of the deceased, no doubt idealized in gaze and feature, but with their individual personalities emphasized. They are usually perched on pedestals striking sententious poses reflecting their social status, and are often accompanied by the accoutrements of their profession. It is in this context that portraits of real women sometimes are present—a wife standing by the side of her husband, occasionally with their children as well. Hardly any

woman made it to the pedestal on her own, outside the home.

Contrasting artistic styles have been employed to reinforce gender differences. The sculptors created women with perfect bodies but without individualized personalities, except for their exquisite expressions of suffering. As lifelike as these figures might appear, theirs is an idealized beauty in sharp contrast to the individualism of the men.

I also wondered whether these women could be religious figures. Again, it would seem not, especially since the cemeteries are filled with madonnas and pietas. The more the Church exercises control, as in Spain or Portugal, the more closely the statues of women conform to traditional Christian religious figures. But the Saving Graces exist outside the Church as well as outside the home.

Well, then, could they be angels? Angels have a prominent role to play, and cemeteries are full of them.[3] But the women who had engaged my interest, no matter how pure and devout, were certainly no angels. One obvious distinction is that angels have wings and the Saving Graces do not. But a more subtle difference has to do with demeanor. As messengers from God, cemetery angels appear sublimely confident of salvation. Sweet and solicitous, they have descended from Heaven to extend comfort to the bereaved. I saw no sad angels.

In contrast, the Saving Graces show a much greater range of emotion—from pain and anguish to despair. They weep, swoon, and beg for consolation, and they do so more in protest than out of conviction. The Saving Graces are not accepting enough to be angels.

There are other important differences as well. Whereas angels are demure, the Saving Graces are sensual, always barefoot. Their gowns are revealing and they are often topless and sometimes nude. In a word, the Saving Graces are sexy. Looking at them, I could certainly appreciate the myth of Pygmalion in which the statue of a beautiful woman returns the longing embrace of her young creator.

For the most part, the Saving Graces are not standardized images but individually crafted, and the sculpture is often of the highest quality. Cemetery commissions must have provided a major source of income for nineteenth-century sculptors. Many well-known artists

whose works are in the Louvre or the Musée d'Orsay also have works in Père Lachaise and the other Paris cemeteries. Such cemeteries serve in effect as vast outdoor museums.

The Saving Graces are linked to a long tradition of Western art in which the naked female figure has been used in both secular and Christian settings to represent a wide range of motifs. Statues of women are found on the facades of government buildings all over Europe and lining squares and public parks. The use of the female nude in public sculpture is common and passes without notice.

Moreover, in Western tradition, the ability to master the female figure is what most defines artistic talent. (The nineteenth-century Ecole des Beaux-Arts and the instructional ateliers of the accepted masters all featured obligatory life drawing classes.) The word "master" seems appropriate, for indeed, the attempt to create the ideal female form is a masculine conceit and one of long standing. As Paul Valéry observed, the nude is for the artist what love is for the poet. Not only were female nudes created *by* men, but one can safely assume they were done *for* men as well; what women might have thought about female figures such as the Saving Graces seems not to have been an issue until quite recently. I wondered about this, too, as I was photographing, curious about exactly who had commissioned these statues and under what terms.

In order for the sensual Saving Graces to have been accepted, the higher moral purpose of the figures had to be utterly convincing. The nineteenth century, when most of these sculptures were made, was a period of changing moralities. Whereas even the hint of nudity in public (outside the cabarets at least) would have been seen as scandalous, one could appreciate naked women in the cemetery not only openly but with a clear conscience and even a sense of moral uplift. Cemeteries are consecrated places, so images that would have been seen as scandalous elsewhere were accepted there as piety. Artists must have relished cemetery commissions not only for the income they provided but also for the opportunity to indulge their creative fantasies in such a noble purpose.

In two years, I photographed hundreds of Saving Graces, and have identified four general types:

First are women so overcome with grief that they have fallen limp on top of the grave or at the feet of the deceased. Since the representations of the deceased are almost always male, some of the distraught women are literally swooning at the feet of men. So overcome are they that their clothing, like their hair, has often come undone and fallen around their waist. Usually they have collapsed face down, but occasionally (especially in Italy) they have swooned on their back, thus fully revealing their uncovered breasts. In their anguish, they are oblivious to their own disarray.

Second, there are the women reaching upward, desperately trying to grasp the (no longer visible) loved one who has just ascended to Heaven. During the nineteenth century, the pain of death lay in the separation it caused until salvation and the moment of inevitable reunion. These Saving Graces are overcome by the pain of this interim loss and are protesting their separation from the departed. These women, too, are barefoot and disheveled, nearly overcome by the loss—even if thought to be temporary—of their loved ones, who in this case are in Heaven above and not in the ground below.

Third are the women virtually shivering with grief who hug themselves tightly or hold their head in their hands, immoble, almost catatonic. Whether naked or clothed, these women reveal less of their bodies. Their hair is up and in place, not loosely falling, and they are turned inward, more self-contained. They seem to by trying to hold themselves together so as to hold in the grief which threatens to spill out at any moment.

Finally, some women seem more resigned to their loss and more accepting of death. Their primary role seems to be to bear witness to the departed. Sitting or standing, and more conservatively dressed, often holding flowers or wreaths by their side, they communicate their grief by the mere stoop of their shoulders or the tilt of their head. Although more stoic than their demonstrative sisters, they too are young, beautiful and sorrowful.

No matter what the style, a characteristic which adds to the life-like realism of the Saving Graces is that usually they are lifesize. In contrast to other public venues for sculpture, cemeteries have very few pieces on a grand scale. The free-standing figures are generally of marble or bronze, though some are made from stone and cast iron. Statues are sometimes weathered and darkened by rain and soot, yet they are still compelling and stand out—just as they were intended to.

Although primarily a phenomenon of the nineteenth century, the Saving Graces are not limited to that period. There are still cemetery commissions today, and some sculptors, seeking to keep the tradition of artistic expression alive, have produced modern versions of the Saving Graces, including some that are quite abstract. Unfortunately, more common in the modern era are "off the shelf" statues, copies of classical or genre nudes ordered from catalogues. These are small scale, often descending to crudely cast figures and of no artistic value.

It is expensive to commission a sculpture or an elaborate commemorative monument, but in the nineteenth century families seemed anxious to spend the money. Of course, wealth was not the only factor; religious, social, and psychological developments in French society during the Revolutionary era also help to explain the phenomenon of the Saving Graces. The cemetery reform movement mentioned earlier placed cemeteries under municipal rather than Church control and inaugurated several profound changes in the way people were buried and commemorated.[4]

Had the separation of the municipal burial from the church funeral not occured, personal and expressive forms of commemoration would not have developed. In addition, for health reasons, the reform movement specified burial in individual graves, and this too encouraged personal markers. For the first time, families could lease cemetary plots on a long term basis. Père Lachaise allowed families to construct monuments, and the long-term leases made elaborate tombs a realistic proposition. Although the expectation was that the upper classes (who had formerly been granted prime burial spots in the churches) might want to avail themselves of this privilege, the idea was enthusistically

embraced by members of the middle class, who evidently viewed commemorative tombs as a way to achieve or confirm social standing that might otherwise be denied them.

I first assumed that monumental egotism was the driving force behind the creation of elaborate tombs and wondered at such blatant display of hubris. But reading the works of the historian Philippe Ariès has led me to believe that the key to elaborate forms of commemoration in the modern European cemeteries was not pride so much as it was the emergence of the family as the primary focus of affection—a profound psychological transformation from what Ariès calls "the love of one's self" to "the love of the other." This rising solicitude for the family tended to produce lavish commemoration; in the context of the times, failure to appropriately honor your loved ones and family would have seemed disrespectful, a public proclamation of indifference. Hubris was incorporated into the family, domesticated. By honoring their families, men got their monuments.

The Saving Graces were one of the most striking aspects of these elaborate commemorations, and they obviously enjoyed great popularity. Their beauty and the quality of the sculpture cannot be overlooked. Nor can their overt sexual appeal. The Saving Graces bring together powerful forces in the two crucial areas where human beings are most susceptible to the potentially wild forces of nature and which societies have thus always sought to regulate through laws and customs—death and sex. According to Ariès, until the late eighteenth century the connection between Eros and Thanatos remained mostly subliminal. But with greater liberalism and freer artistic expression, the erotic link became more explicit, reaching full flower in the Romantic era of the early nineteenth century. In art and eventually in the popular consciousness, the idea of death came to inspire not horror and fright but love and desire. The Saving Graces make this close association explicit and give it tangible form.

The Romantics were infatuated with death; for them, death was the focus of extreme emotion and the ultimate expression of love. "To die loving you is better than life itself," Alfred de Musset wrote pas-

sionately to George Sand. Theirs was the era of the "beautiful death," in which death was conceived as attaining "a desirable and long-awaited refuge," as well as a rebirth. And just as birth is linked to sex, the instant transport from death to eternal life (rebirth) was symbolized by a release similar to sensual pleasure. Eroticism, after all, is often a liberating force. It is no accident that these women's expression of agony is sometimes indistinguishable from ecstacy. Many of the Saving Graces are very convincing. No doubt that is why the Romantic Théophile Gautier declared: "I always prefer the statue to the woman and marble to flesh."

Some see the Saving Graces as the embodiment of death itself, the theory being that if death is represented by these gorgeous and sensual young women, its sting will be removed. Men will welcome death and want to embrace it willingly, even anxiously: "Sweet is death who comes like a lover." This theory says nothing about how willingly or why women might want to embrace death.

After two years spent photographing European cemeteries, I have reached a somewhat different conclusion. Although commemorative tombs certainly seek to validate a life past and establish a historical record for the individual and the family (no doubt with whatever embellishment seems necessary or appropriate), tombs also seek to make as persuasive a case as possible for life after death. I see cemeteries as places of infinite optimism where eternal life takes precedence over mortality. Death is not denied, but neither is it celebrated. Rather, death is displaced in the cemetery as the focus there turns from the temporal past to the eternal life ahead. Monuments are instruments of both tribute and hope, and the Saving Graces have a role to play in each, reflecting the dualism of the cemetery. On the one hand, they are the grieving women who signify how deeply the deceased is missed. As symbolic mourners, their idealized beauty is spiritual, representing purity, passion, and commitment. And the more beautiful they are, the greater is the grief, the more tragic and profound the loss.

But these women also serve as escorts on the journey ahead. As designated companions in eternity, they are posted there to watch over

and take care of the deceased. Forever present, they are also forever young, conveying the same power of rejuvenation (and prestige) to the deceased as the young trophy woman does on the arm of an older man. To me, these women symbolize the aspiration for eternal life, not the acceptance of death. They may grieve, but they also comfort, and in this role, their beauty is more sensual than spiritual. The more beautiful they are, the more vigorous life after death will be and therefore the more certain we are of immortality.

Pure on the one hand, sensual on the other, idealized yet lifelike, the Saving Graces inspire a very human combination of spiritual devotion and earthly desire. If angels are God's intermediaries, the Saving Graces are ours.

— DAVID ROBINSON

Boston • November 1994

E N D N O T E S

1. My photographs were consciously restricted to what I call the "modern cemeteries"—those dating form the nineteenth-century reform movement, of which Père Lachaise was the first. In the beginning, I simply was not interested in the staid churches and official mausoleums like Saint Denis or the Panthéon or Westminster Abbey. Later, when I understood what a break with the past Père Lachaise represented, I realized that it was in the modern cemeteries that I would find a greater variety of commemorative forms. With the modern municipal cemeteries, the tight control of the Church was broken, and families could be freer in their expressions of mourning.

2. In Montparnasse, I thought I had indeed discovered a weeping man: a statue of a naked man holding his head in his hands and standing next to a woman who was lowering the tombstone over herself. But I later found out that this statue did not mark any grave but had been relocated from the Jardin de Luxembourg, where it was presumably too risqué, and put into the Montparnasse cemetery where it would be less obtrusive.

3. Cemetery angels are either females or children (cherubs). I cannot recall seeing a masculine angel or even an androgenous angel, except for the putti. This seems to represent a considerable variation from classical Greece and early Christianity, when angels were both male and female and were depicted as such.

4. Père Lachaise, which opened in 1807, became the model for the "modern" cemeteries created as a result of the general reform movement that spread throughout Europe and to America during the nineteenth century. Thus, many of the forms of commemoration originally specific to Père Lachaise, such as the Saving Graces, were copied extensively elsewhere.

BIBLIOGRAPHY

Although most of my comments are based on personal observation, while photographing, I supplemented my first-hand experience with whatever written sources I could find locally. I continued this reading and research after I returned to the USA. A list of works consulted follows.

Philippe Ariès. *The Hour of Our Death*. New York: Oxford University Press, 1991.

———. *Images of Man and Death*. Cambridge, MA: Harvard University Press, 1985.

Jaques Barozzi. *Guide des Cimetières Parisiens*. Paris: Editions Hervas, 1990.

André Chabot. *Erotique de Cimetière*. Paris: Henri Veyrier, 1989.

Kenneth Clark. *The Nude*. London: Penguin Books, 1985.

Marcel le Clère. *Guide des Cimetières de Paris*. Paris: Guides Hachette, 1990.

James Stevens Curl. *A Celebration of Death*. London: B. T. Batsford, 1993.

George Ferguson. *Signs and Symbols In Christian Art*. New York: Oxford University Press, 1984.

Jean-Louis Jolas. *Père Lachaise, Théatre d'Ombres*. Paris: la Maison Rhodanienne de Poèsie, 1990.

Robert and Beatrice Kasternbaum. *Encyclopedia of Death*. New York: Avon Books, 1993.

Josette Jaquin-Philippe. *Les Cimetières de Paris*. Paris: Leonce Laget, 1993.

Margaret R. Miles. *Carnal Knowing: Female Nakedness and Religious Meaning in the Christian West*. New York: Vintage Books, 1989.

Lynda Nead. *The Female Nude: Art, Obscenity and Sexuality*. New York: Routledge, 1992.

Greg Palmer, *Death, the Trip of a Lifetime*. San Francisco: Harper Collins, 1993.

Martha Pointon. *Naked Authority: The Body in Western Painting, 1830–1908*. Cambridge: Cambridge University Press, 1990.

Marina Warner. *Monuments and Maidens: The Allegory of the Female Form*. New York: Atheneum, 1985.

Peter Lamborn Wilson. *Angels: Messengers of the Gods*. London: Thames & Hudson, 1994.

Technical Notes

When I photograph, my style is to walk without a definite destination or route, some-times for hours at a time (cemeteries are perfect for this). So I keep my equipment light-weight and simple; I carry two Nikon FM2 cameras, each with a 55mm lens plus a 200mm telephoto and a 24mm wide-angle lens for use if needed. Since I am always on the move, I do not wait for weather or light conditions to change, nor do I arrange any-thing in the scene. All the photographs were taken with natural light and with a hand-held camera. (No flash, no tripod.) The film I used was Kodak TMX 400 and occasional-ly TMY 100.

Prints

Prints of the photographs in this book are available. Please contact David Robinson at 15 Upland Avenue, Mill Valley, CA 94941 or at drphoto@well.com.